Decaying Barns of North America

A Colouring Book by Carl Plainer

Copyright © 2012 by Carl Platten.

Library of Congress Control Number: 2012905920
ISBN: Hardcover 978-1-4691-4932-5
 Softcover 978-1-4691-4931-8
 Ebook 978-1-4691-4933-2

National Insurance Number 361920

All rights reserved. No part of this book may be reproduced or transmitted in any form or by any means, electronic or mechanical, including photocopying, recording, or by any information storage and retrieval system, without permission in writing from the copyright owner.

This book was printed in the United States of America.

To order additional copies of this book, contact:
Xlibris Corporation
0-800-644-6988
www.xlibrispublishing.co.uk
Orders@xlibrispublishing.co.uk
303102

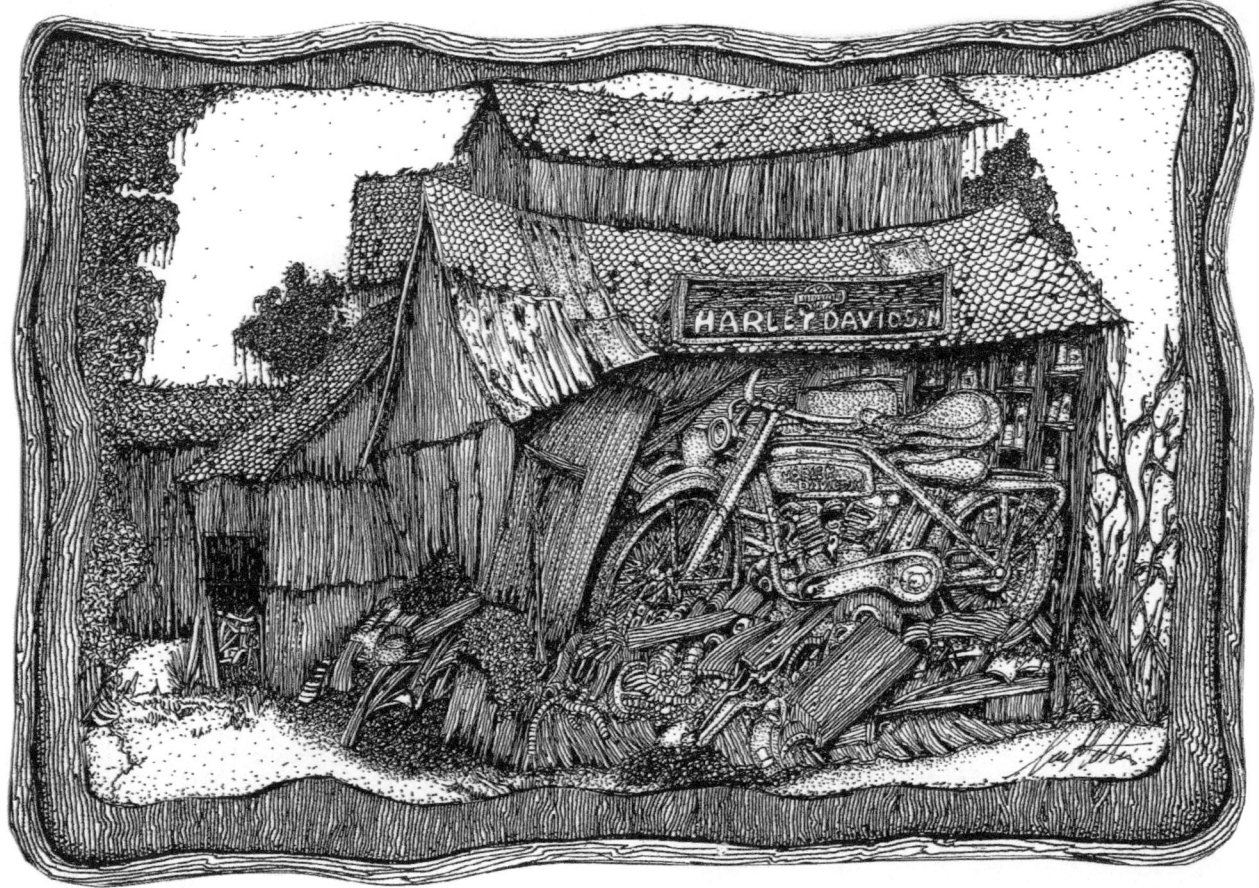

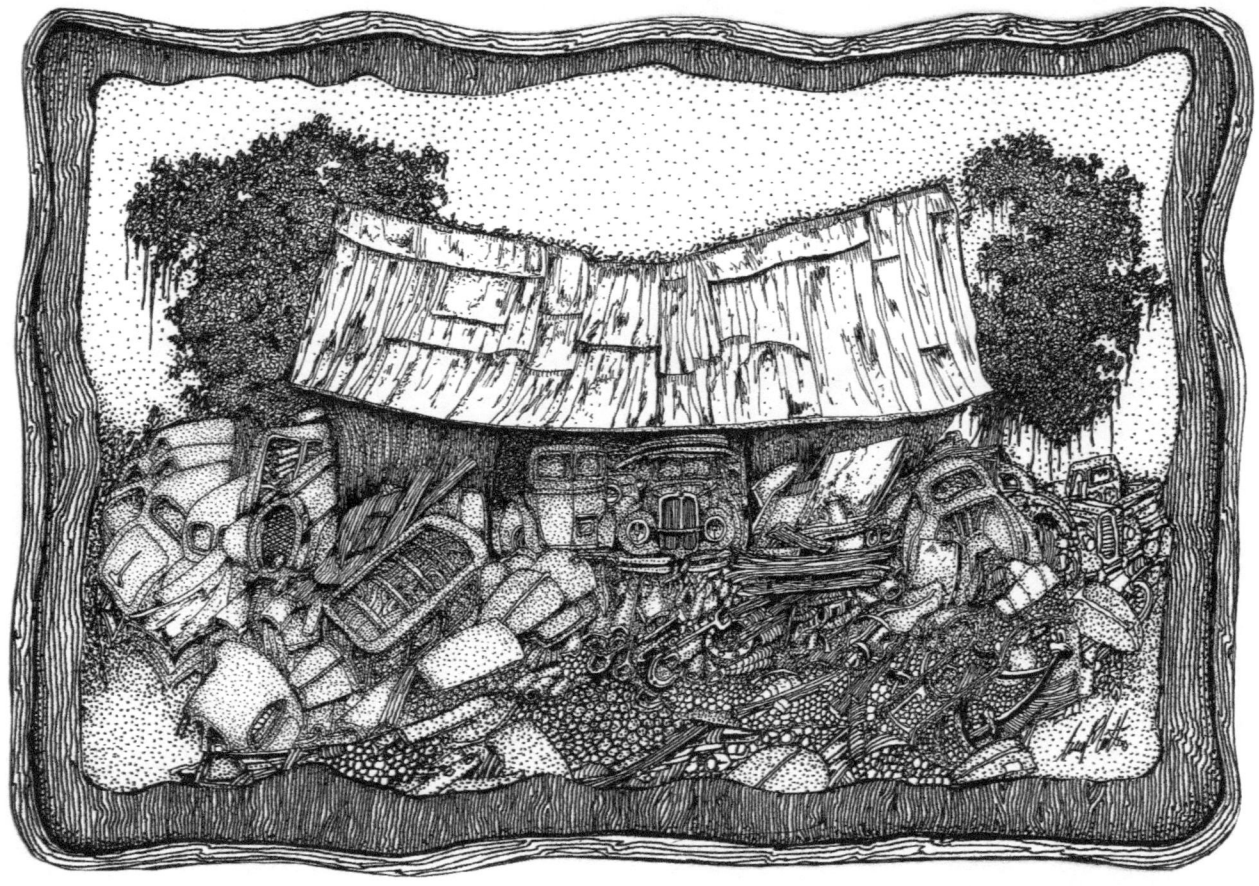

Decaying Barns Of North America

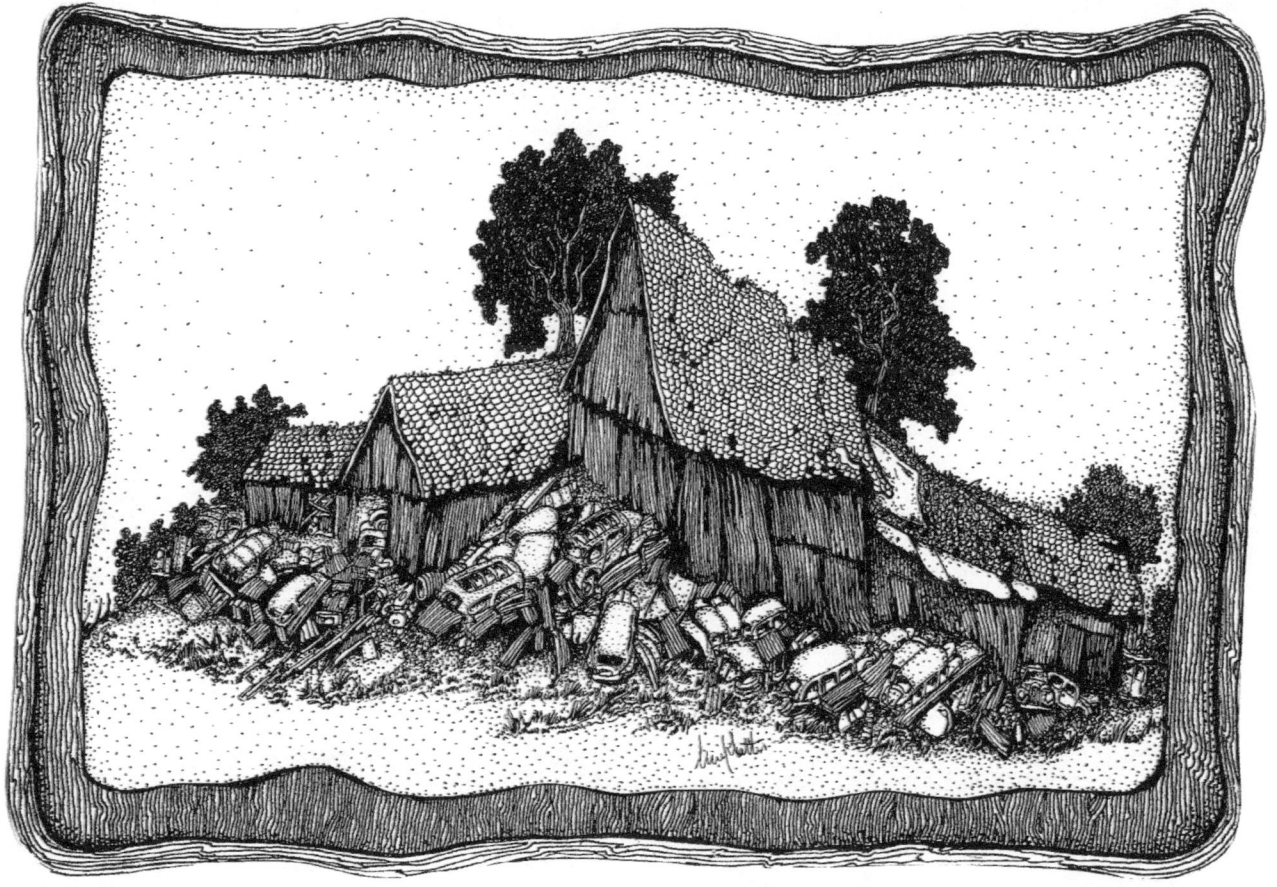

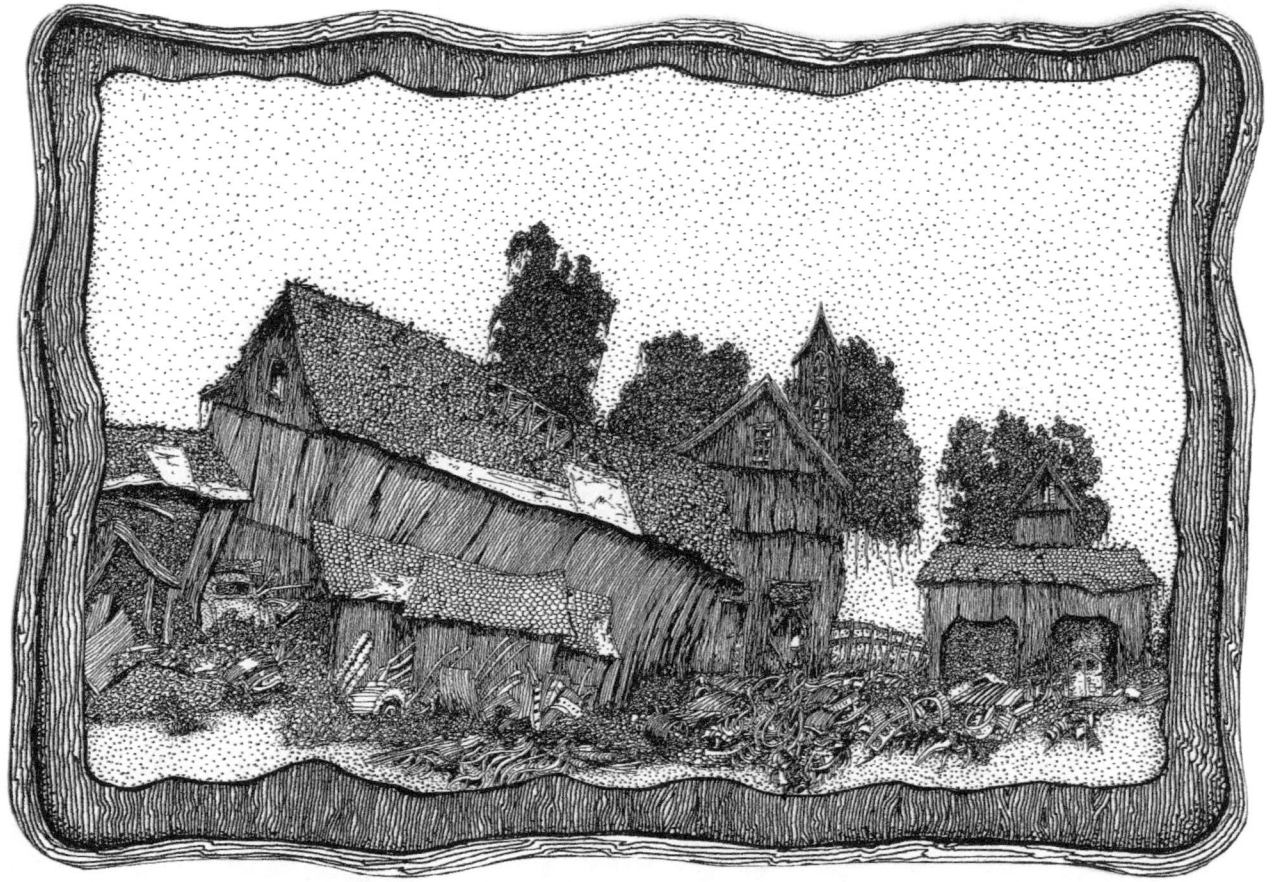

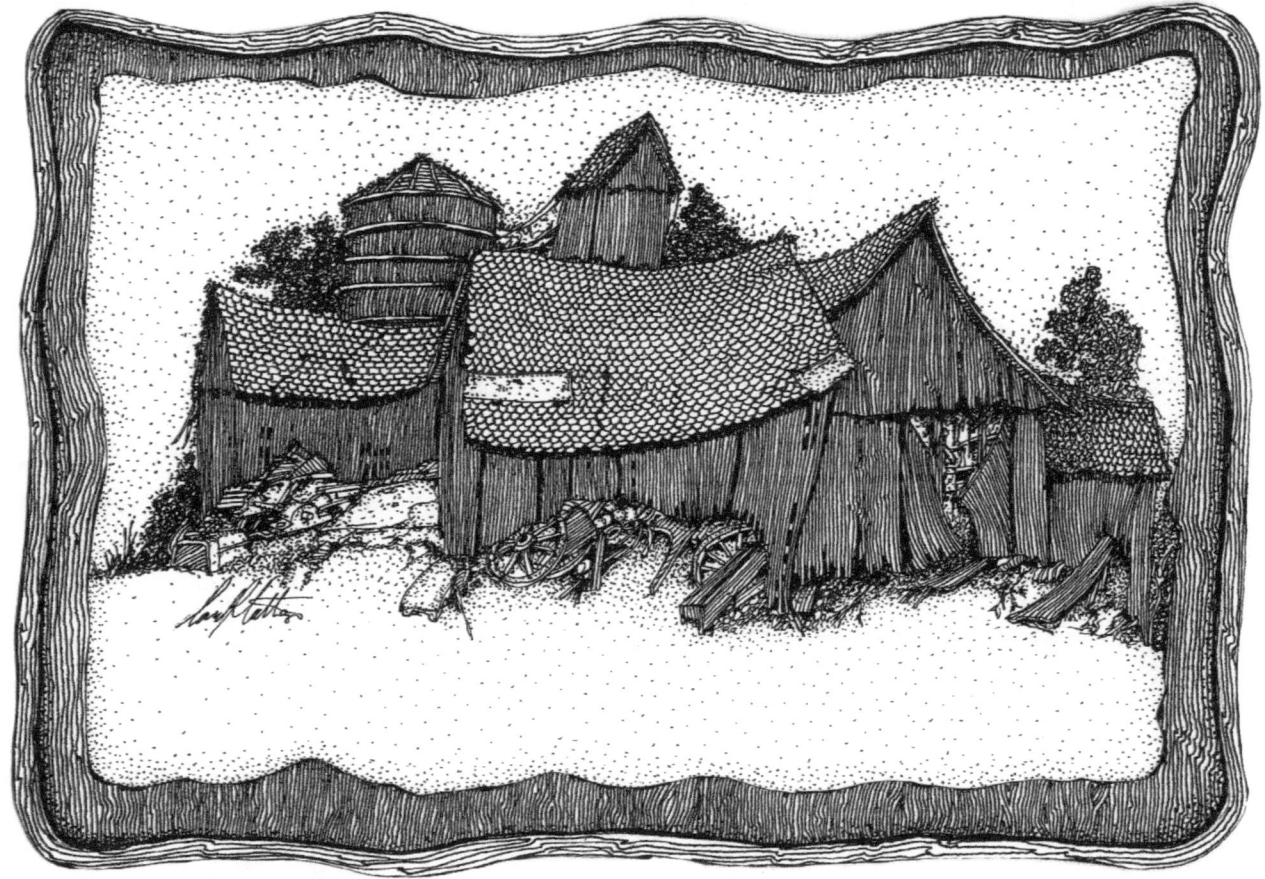

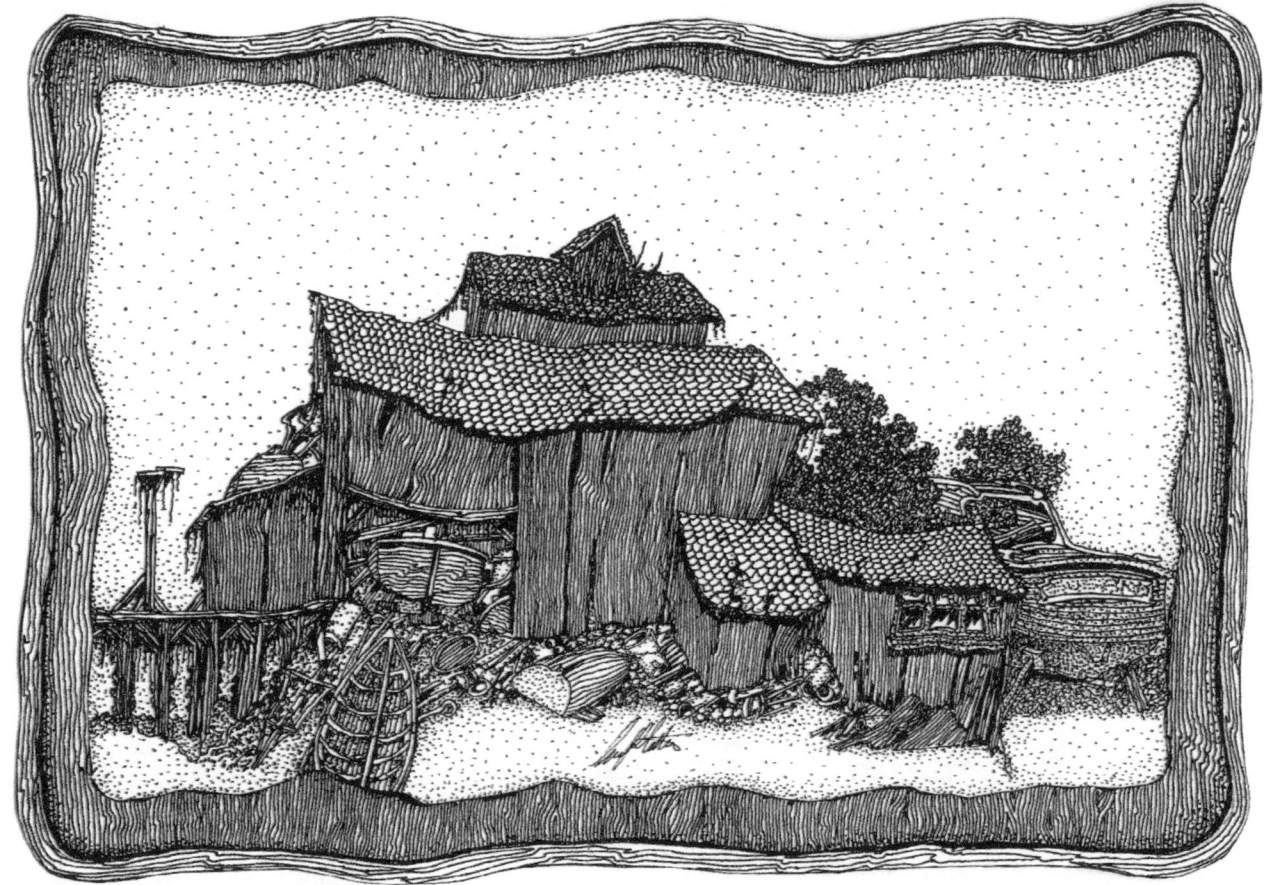

Decaying Barns Of North America

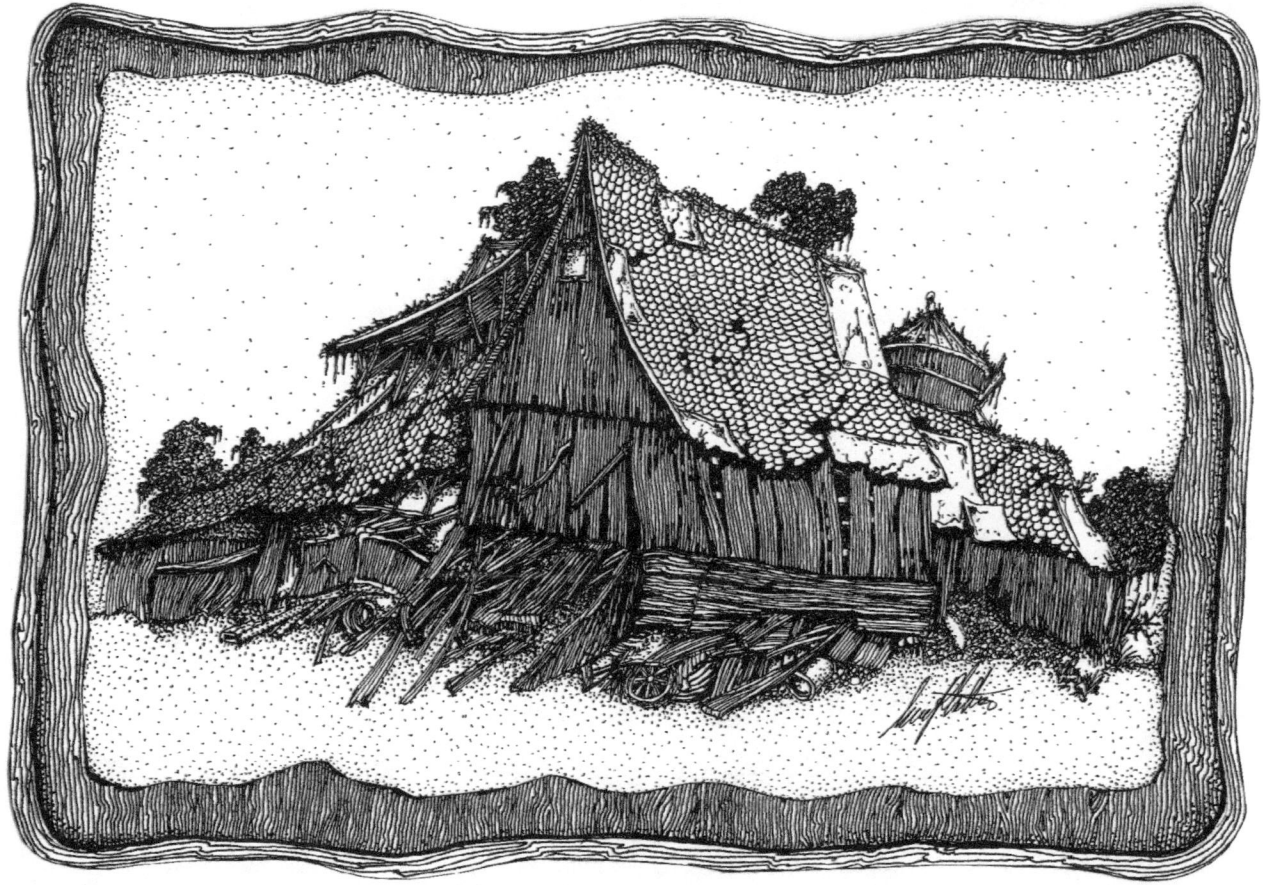

Decaying Barns Of North America

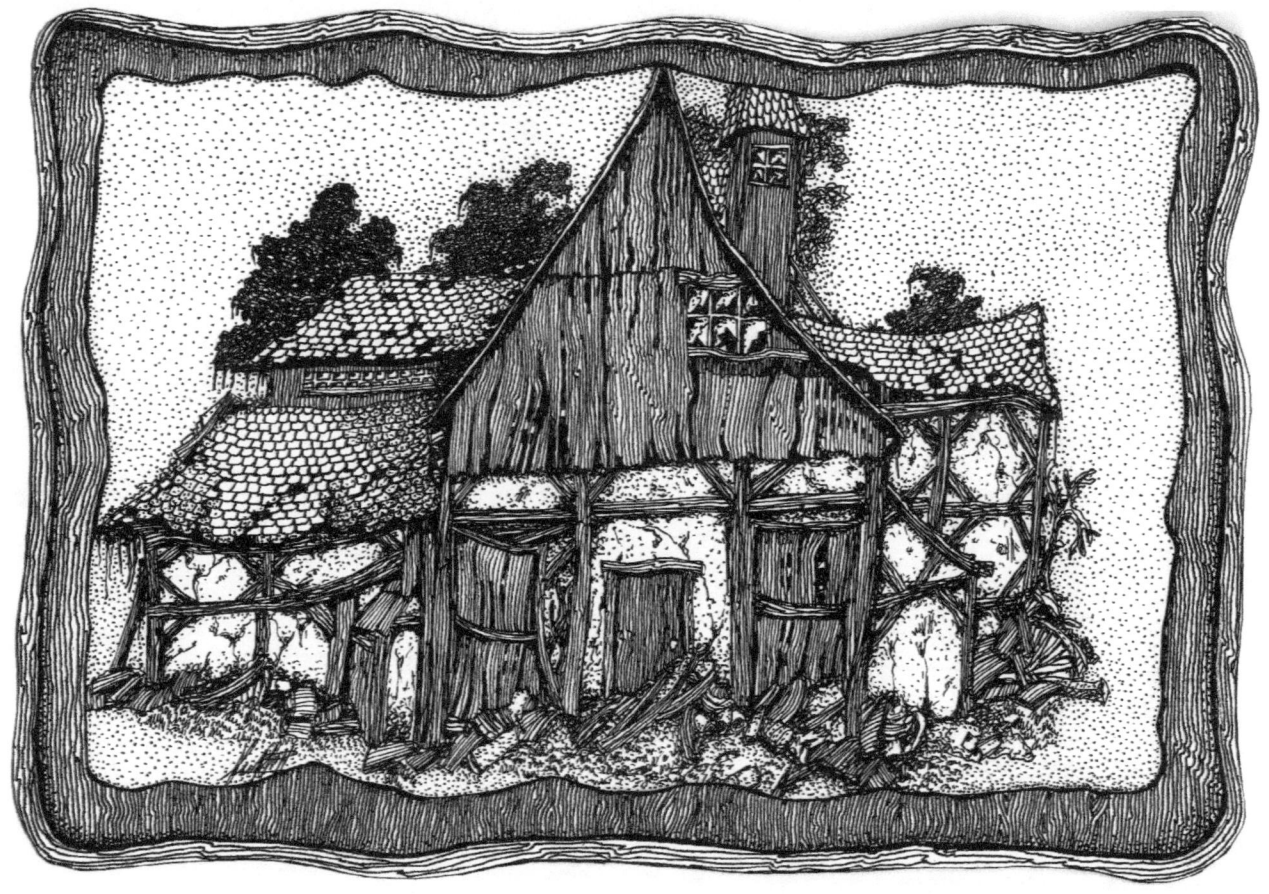

Decaying Barns Of North America

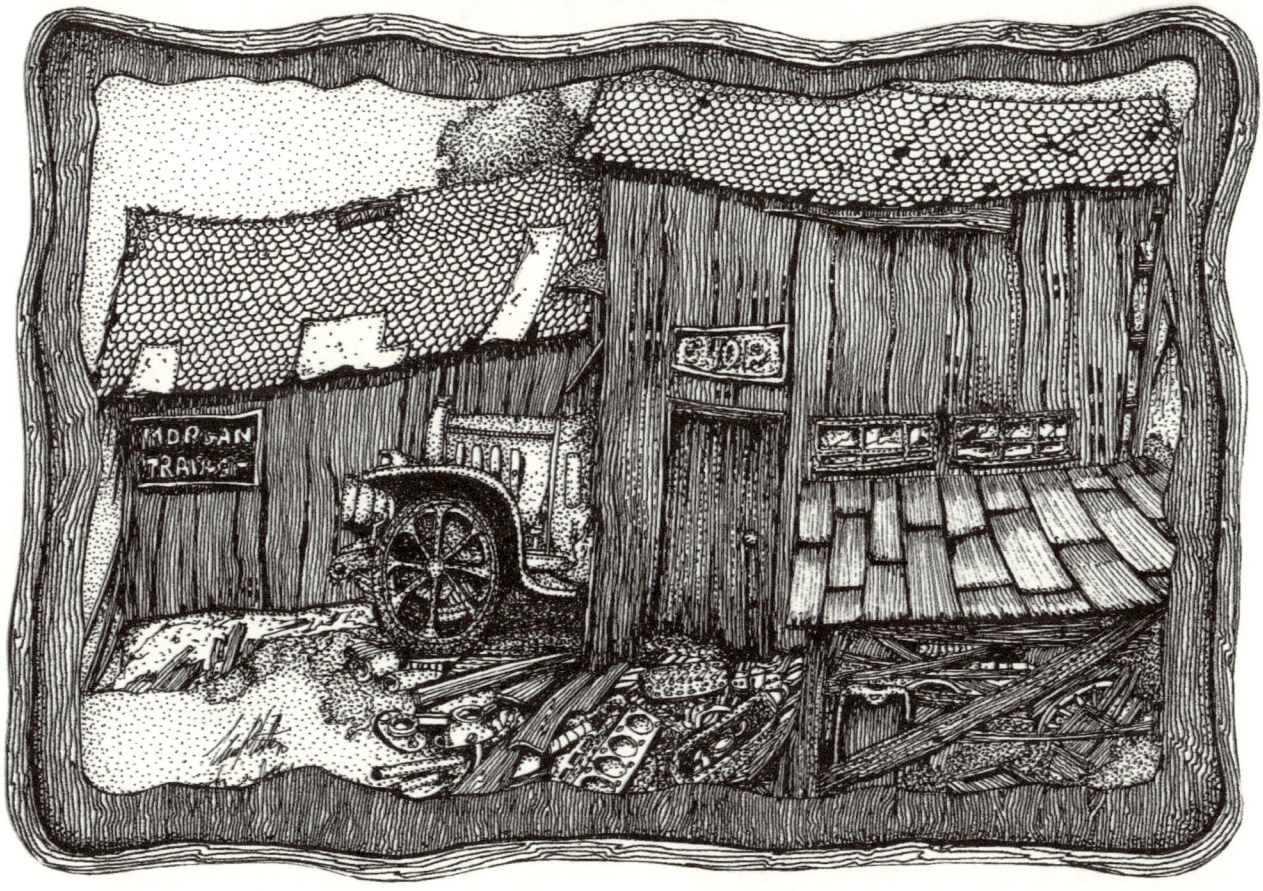

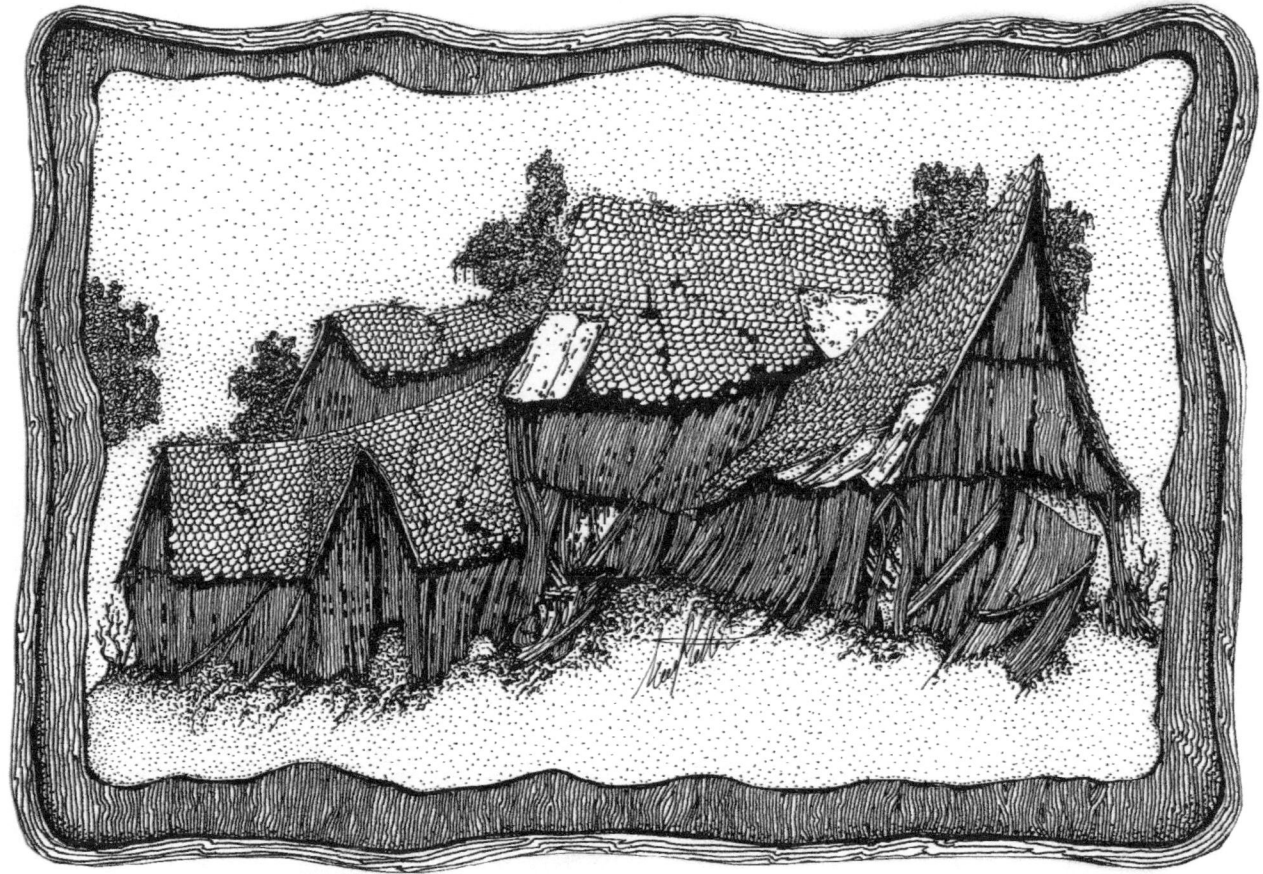

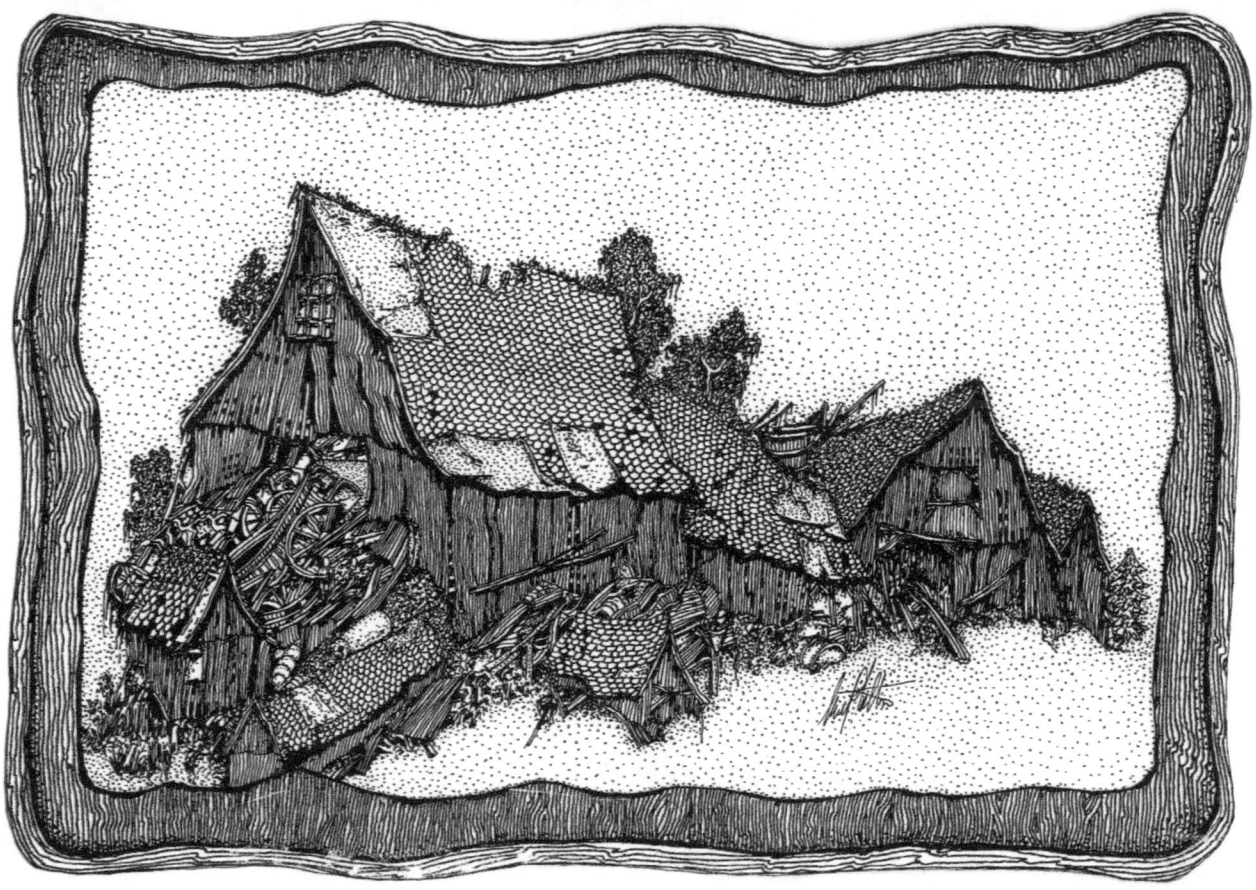

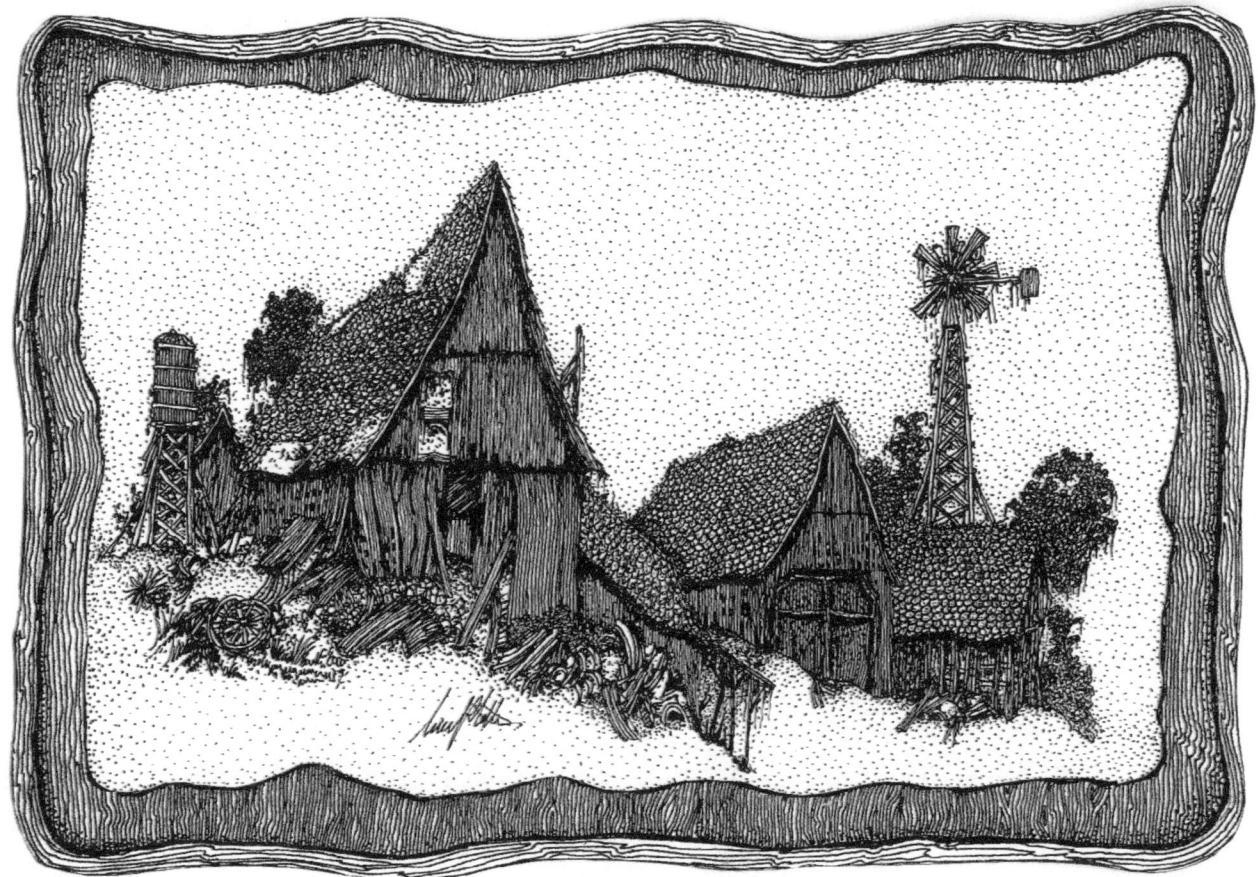

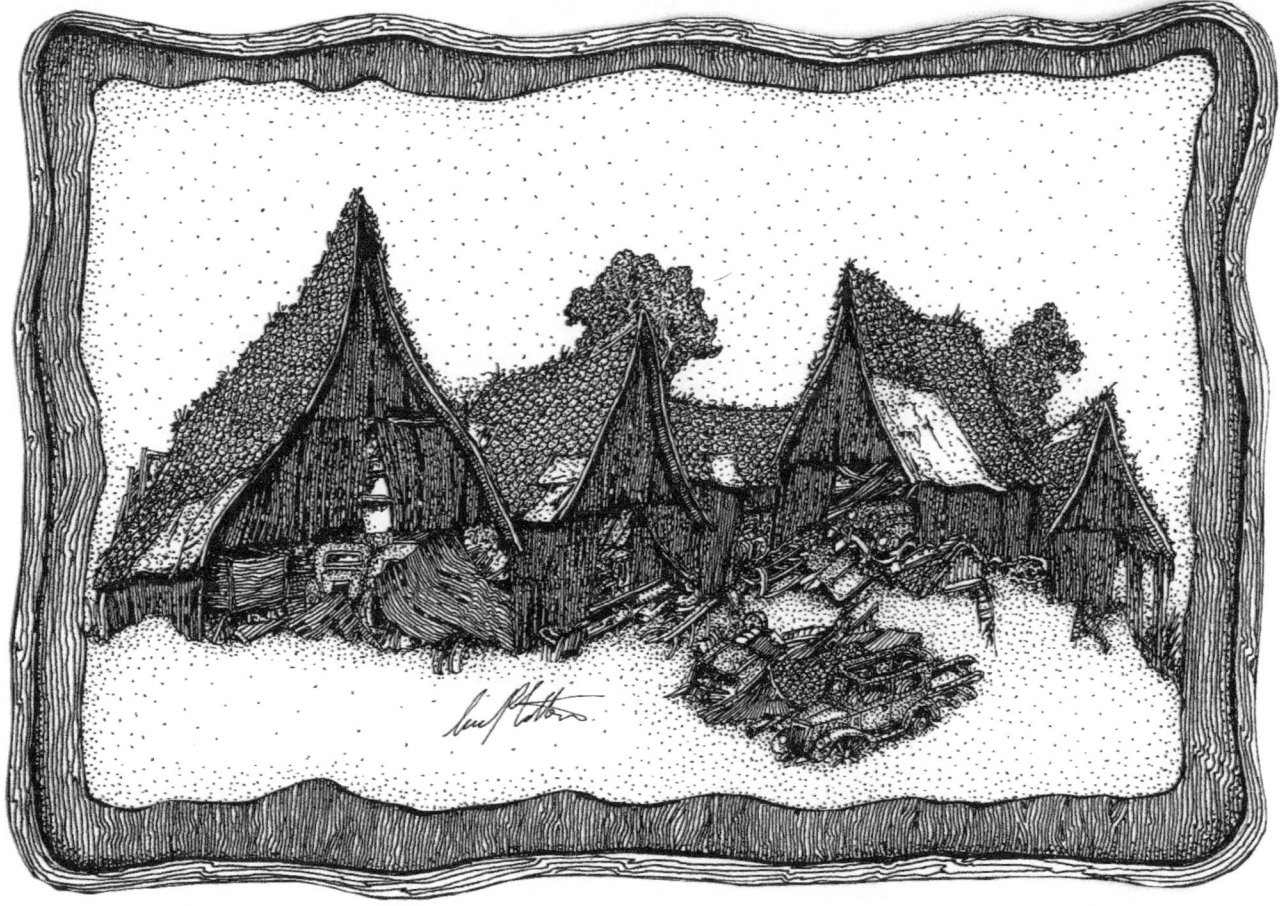

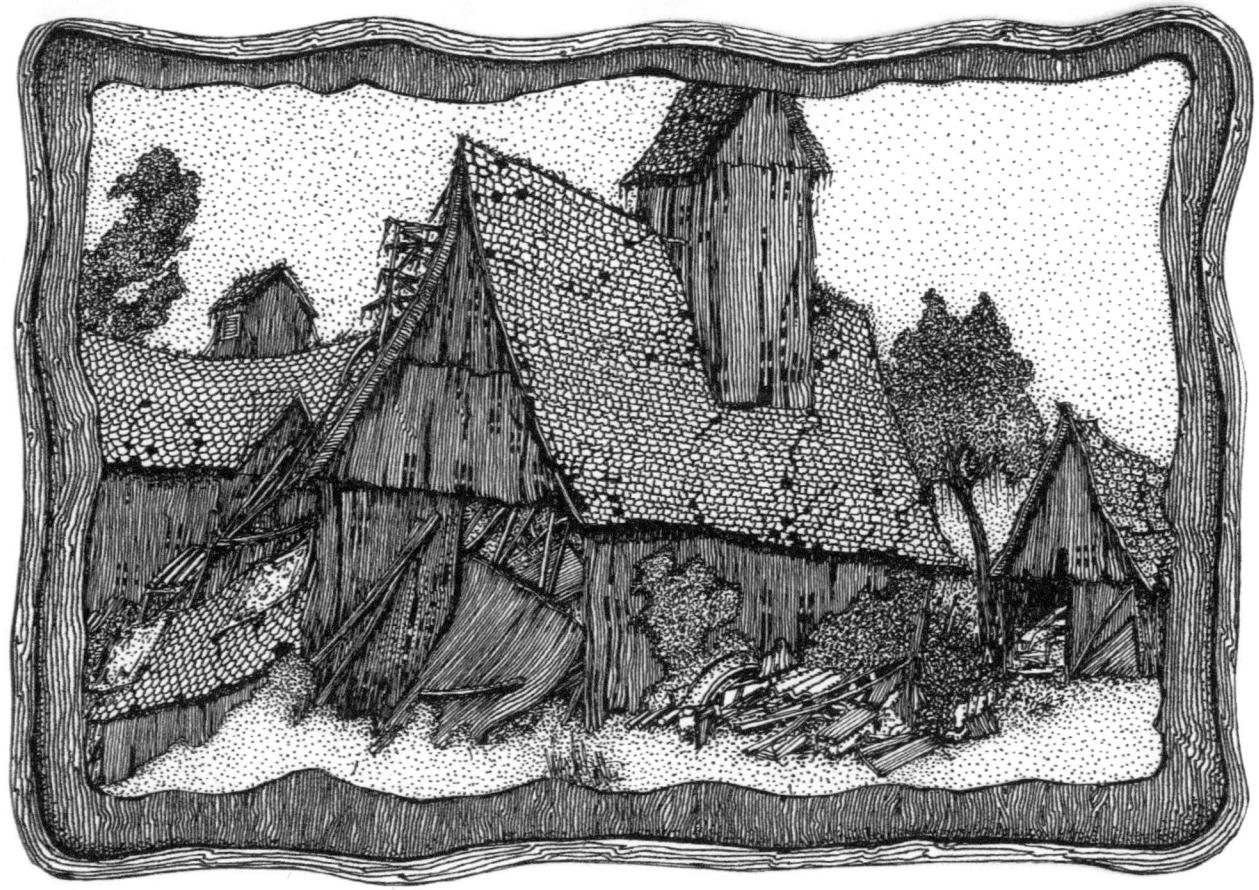

Decaying Barns Of North America

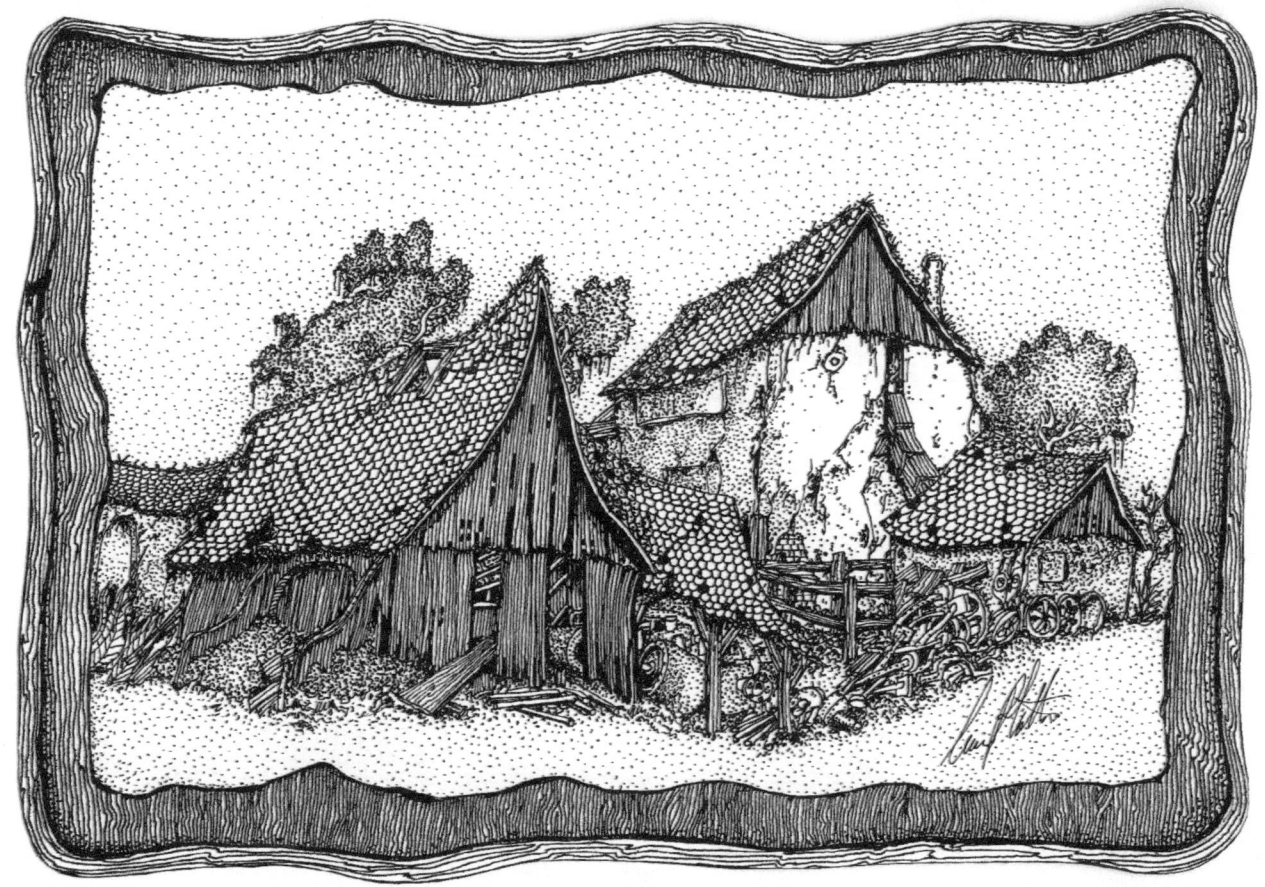

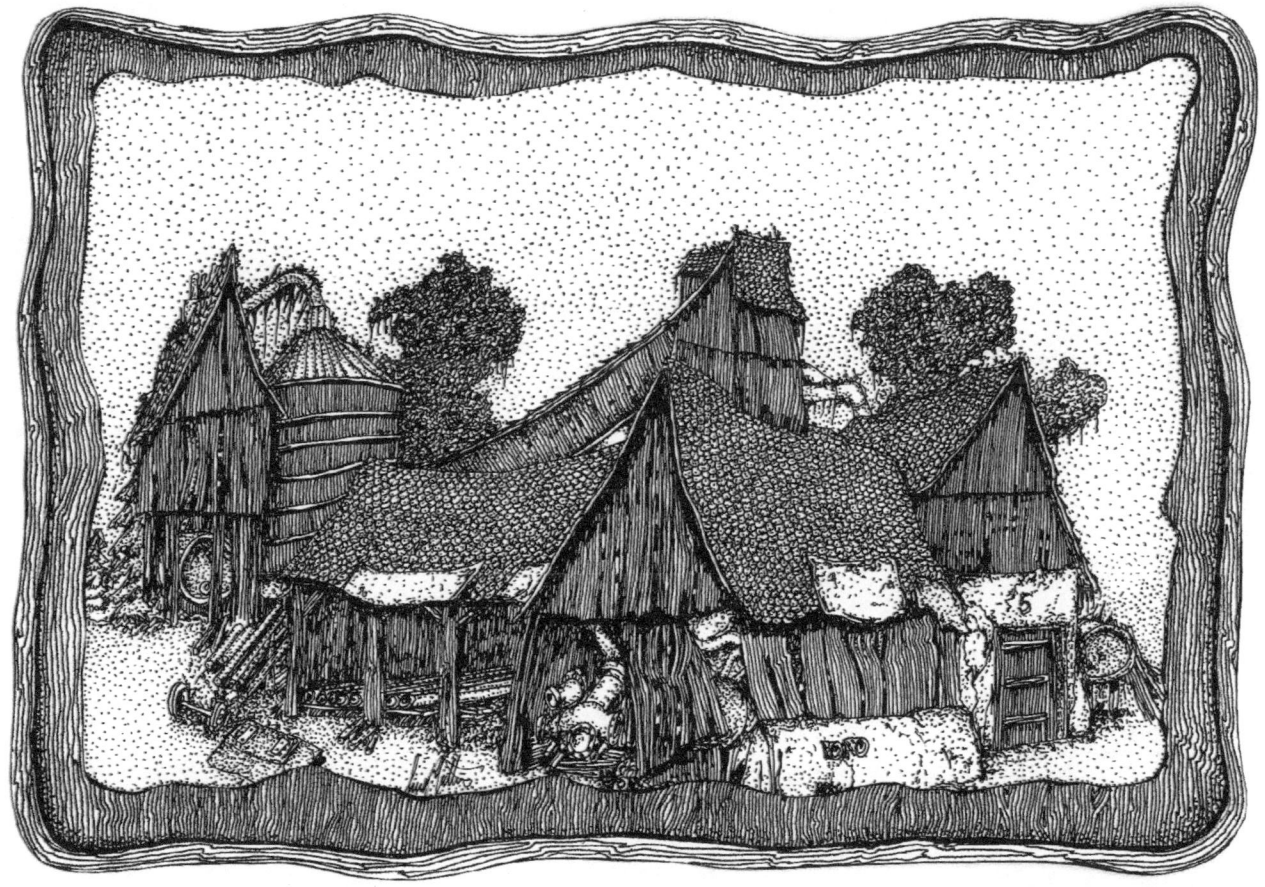

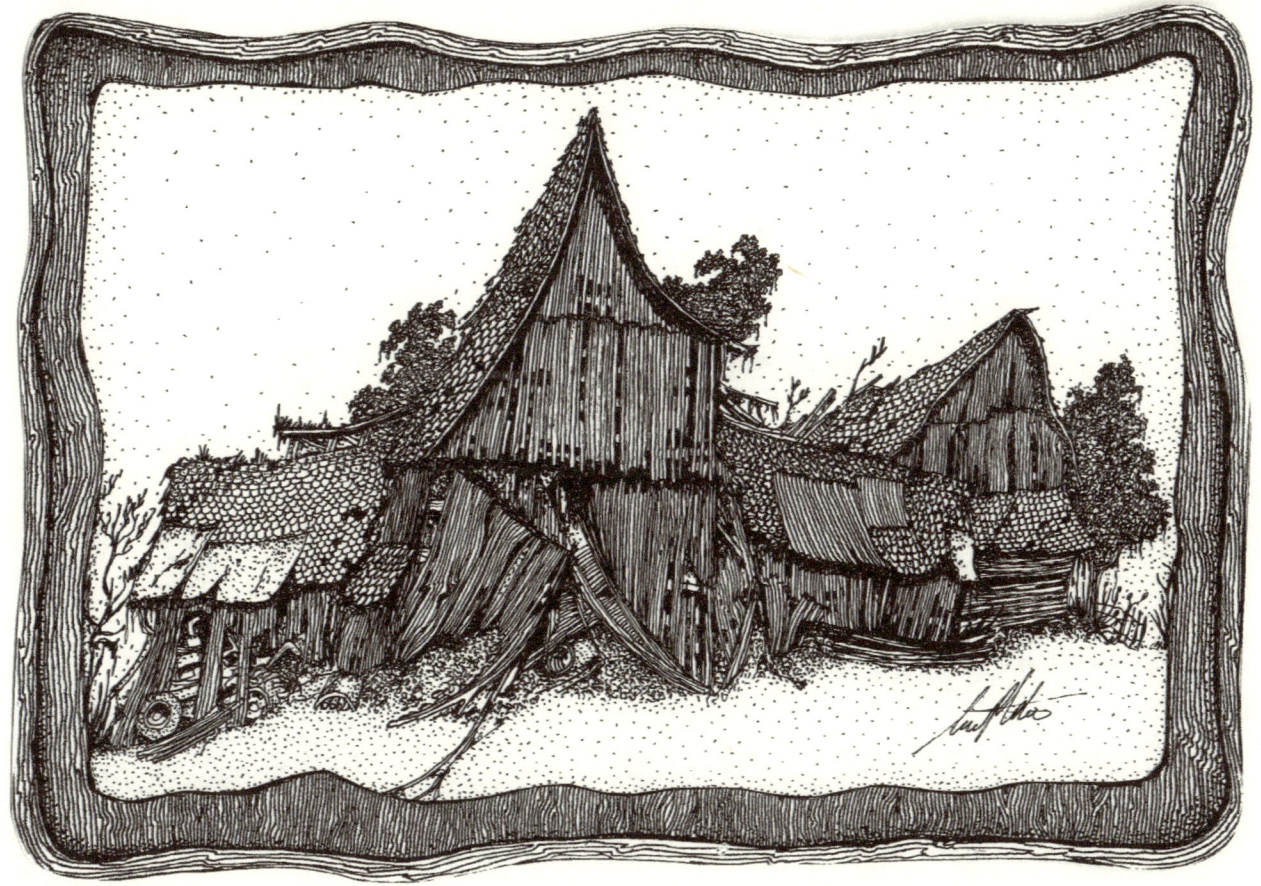

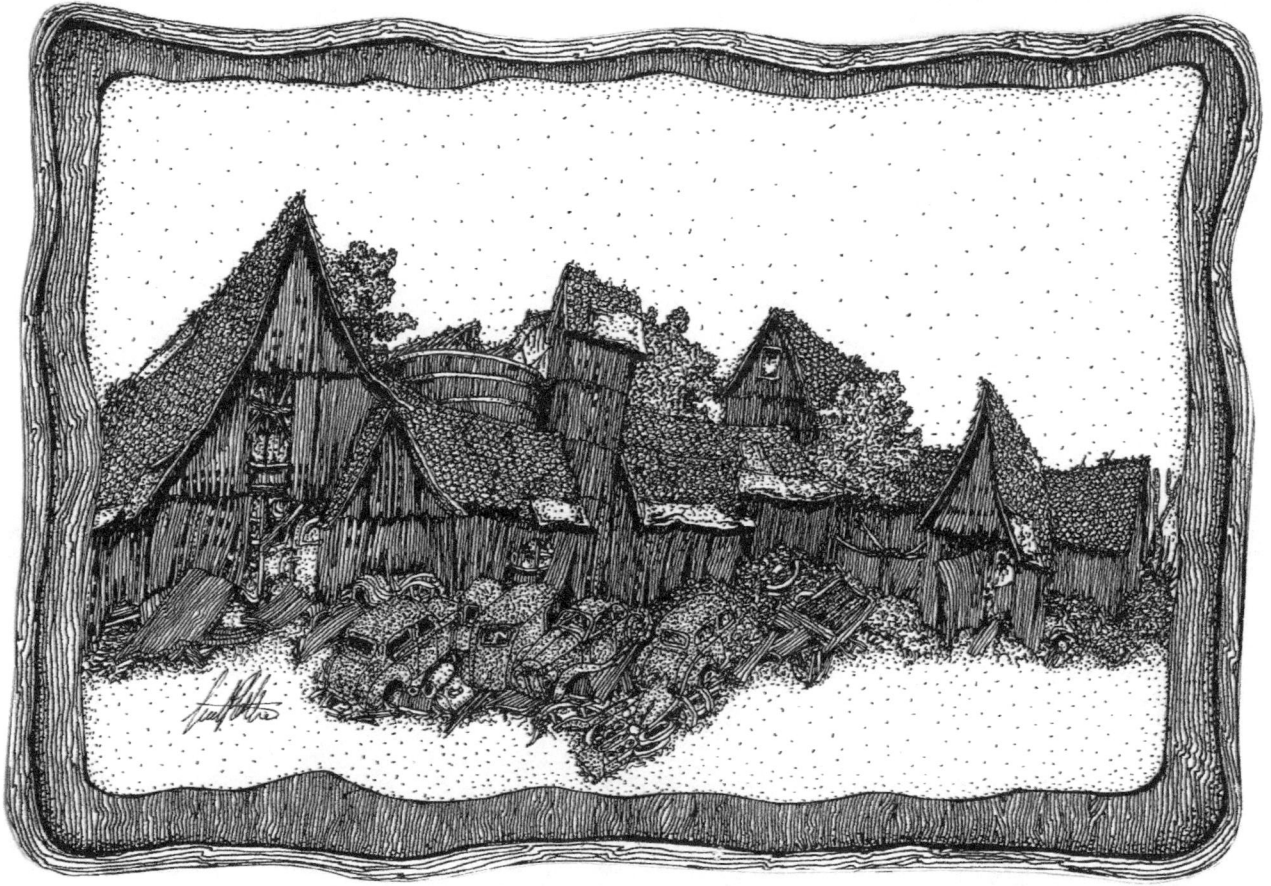

Decaying Barns Of North America

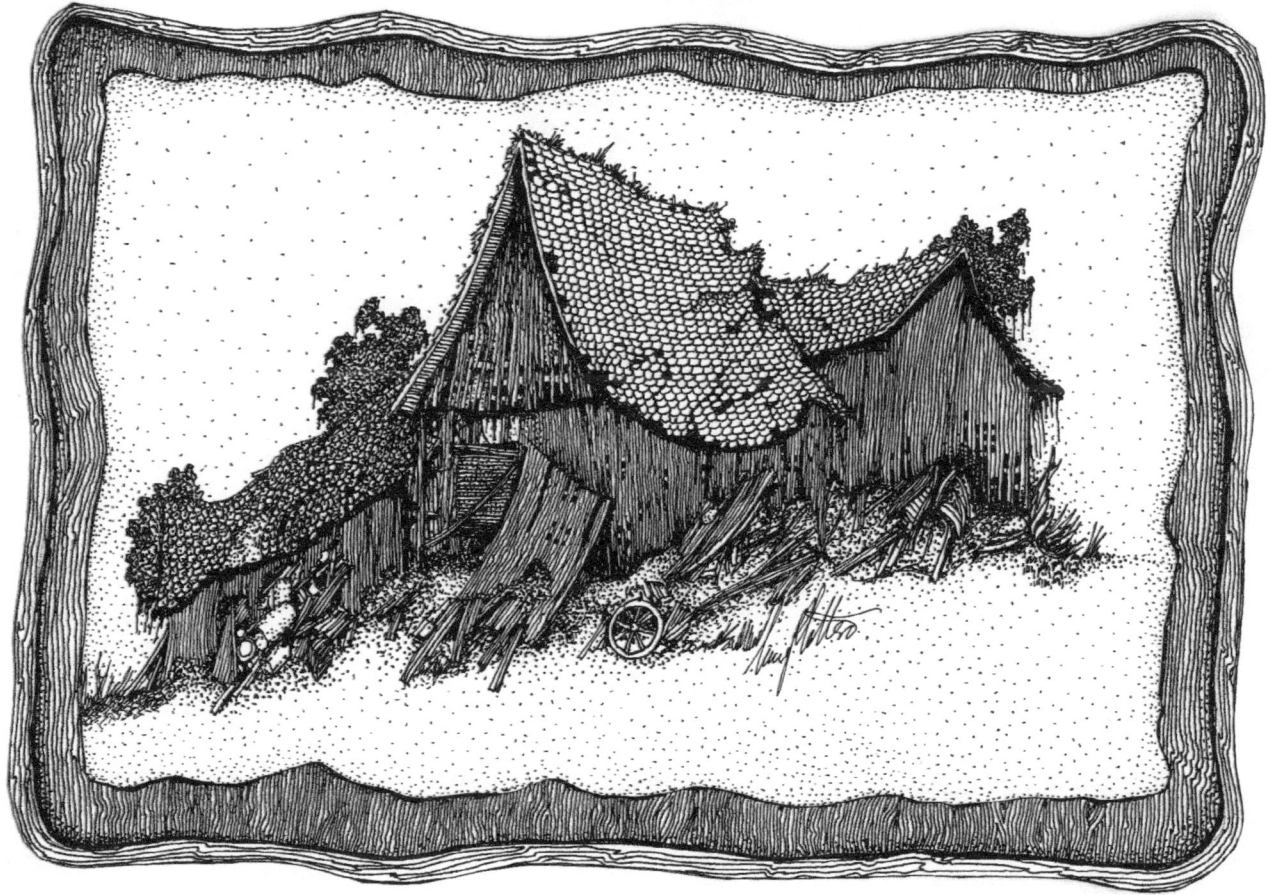

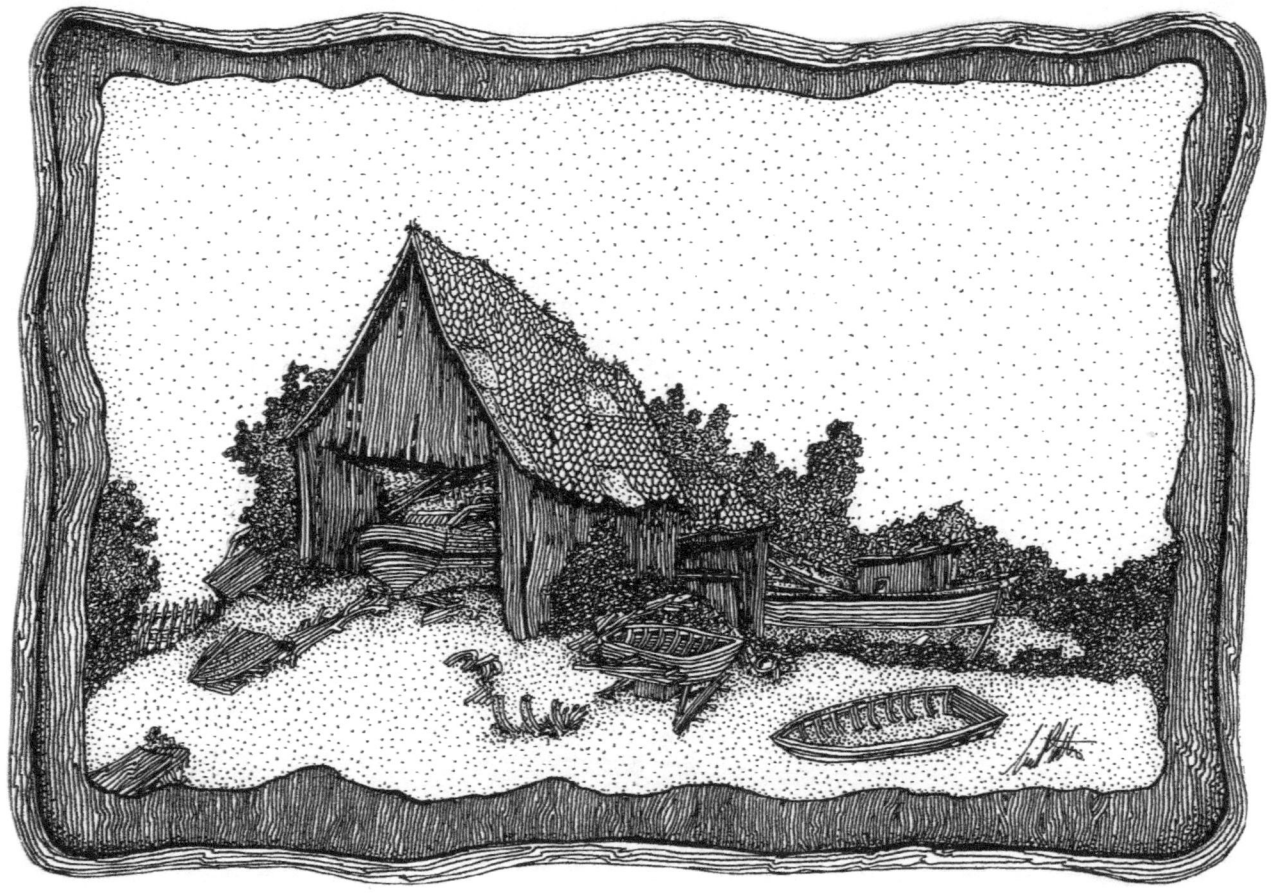

www.ingramcontent.com/pod-product-compliance
Lightning Source LLC
Chambersburg PA
CBHW021049180526
45163CB00005B/2345